# Gavin Turk

# Gavin Turk

Collected Works 1994–1998

Jay Jopling (London)

Co-ordinated and edited by Honey Luard
Co-edited by Zoë Manzi
Designed by Jonathan Barnbrook and Jason Beard
Photography Stephen White, Johnnie Shand Kydd, Jean-Marc Borghero,
Aurel Schiebler Galerie, Feeringbury VIII. Cultivated/Johnny Volcano
Printed by Smart Arts Limited, Brighton

Fifteen hundred copies of this book have been
published by Jay Jopling in association with
the South London gallery to accompany the exhibition
**Gavin Turk: The Stuff Show**, South London Gallery, London,
9 September - 18 October 1998

Jay Jopling/White Cube          South London Gallery
44 Duke Street                  65 Peckham Road
St. James's                     London SE5 8UH
London SW1Y 6DD                 tel +44 171 703 6120
tel.  + 44 171 930 5373
fax. + 44 171 930 9973

With the support of The Henry Moore Foundation

ISBN 0-9522690-3-1

With thanks to South London Gallery, White Cube,
Seorais Graham, Deborah, Curtis and Frances

**0** 1 2 3 4 5 6 7 8 9
    0 1 2 3 4 5 6 7 8 9

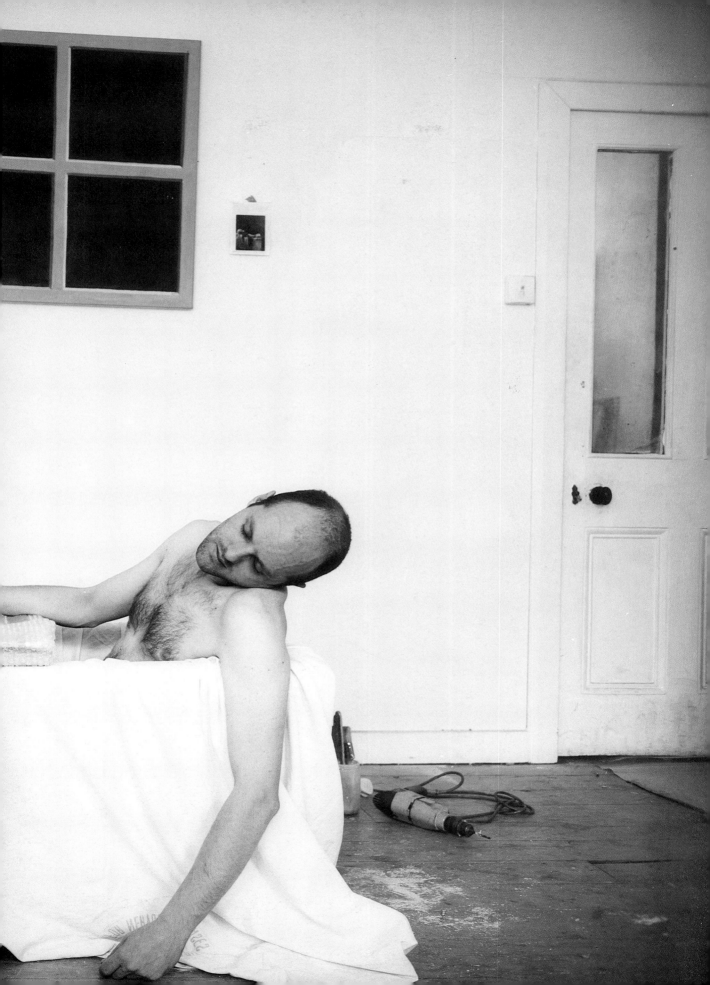

# Tonight, Manzoni, I'm Going to be Gavin Turk

*Alex Farquharson*

Egg Man, Everyman, **Godot**. A man in a dark suit and conservative tie occupies the foreground of a large photograph. A Gainsborough-style stretch of golden Home Counties countryside runs behind his head. The head, though flesh tinted, is no head. It hasn't eyes, a mouth, a nose or ears. It's as though these features have been airbrushed out, and our stereotypical well-heeled commuter-belt executive is in fact a retro pointy-headed alien. His swelling, on close inspection, turns out to be an immaculate, outsized egg, which gives this 'suit' the appearance of having re-located to Blair's Britain from what had been René Magritte's Belgium between World Wars. Photographed rather than painted, this bourgeois mutation, carrying displaced surreal and existential baggage, seems to have migrated via the embarrassingly *passé* Magrittian look of 1970s Pink Floyd album covers courtesy of 1990s City advertisers. In so doing the image has degraded, irrecoverably. One half expects the image to be accompanied by jingle, catchphrase and logo, Wittgenstein style. No longer just a stereotype of the 'modern man' lost and alone in an absurd world (it is titled **Godot** after Samuel Beckett just to rub it in), the figure photographed recycles a clichéd motif of that stereotype. The Magritte citation is not towards any original painting but to the journey that the 'original' image has taken through art history and commercial pastiche, a migration that has had the effect of all but effacing any true sense we might have of the primary source.

The man wearing the egg for a head is one Gavin Turk, a British artist a whisker over thirty whose arrival on the art scene was inaugurated by his own death. A blue plaque, of the kind one sees stuck to the facades of countless London residencies commemorated the deceased dignitary's working years as a sculptor in his studio at the Royal College of Art, Kensington Gore, London W1. Since 1991 Gavin Turk, the artist, has been busy being born with a variety of illustrious avant-garde elders on hand as midwives: Manzoni, Klein, Duchamp, Magritte,

Dali, Johns, Warhol and others. Recently, last year in fact, one could hear the sound of **One Thousand, Two Hundred and Thirty Four Eggs** cracking, heralding his imminent arrival perhaps. The eponymous 'painting' (medium: white egg shells on canvas) is etched through with a six foot Gavin Turk signature. The artist's signature, that most common sign of identification and authorisation, is delineated by smashing the relevant eggs through a whole field of eggs, (the egg, of course, being a quintessential organic metaphor for origin and originality). This might seem an entirely vainglorious affair until one spots the references and realises that this enormous statement of identity is a series of layered references to the artistic identity of another. Not just any other, but Piero Manzoni, whose *oeuvre* may well be art history's most outrageous statement of authorial omnipotence. Not content with a single citation Turk has overlayered three recurrent Manzoni motifs – the egg, the signature and the Achrome (his white matter paintings) – a cross-referencing that has the effect of looping and cancelling out the symbolic aspirations of each.

In 1960 Piero Manzoni made art works from eggs which he boiled then marked with an ink thumb-print in front of an audience. In contrast to Duchamp's readymades, which were deadpan, anti-aesthetic designations, Manzoni's appropriations were highly metaphoric acts of transformation, that were more about the act of energising ordinary substances than the ontology of objects. The poverty of the materials underlined the artist's powers of ordination. The artist's signature or some other indexical imprint of the artist's body was the agency of transubstantiation. A human being might be a 'Living Sculpture' if signed by Manzoni, or whilst standing on one of his plinths. Even air might be art if it happened to have been breathed by Manzoni into a balloon. So might his shit and Manzoni had one hundred samples of it canned. Viewed from the antipodes the whole world was art, since it 'sits'

on Manzoni's **Socle du Monde**, a large cubic plinth sited in Milan. Through contact with the artist a base material is transfigured or alchemised by an act of transcendent authorship.

But what happens when the 'original' idea is done again by someone else? Like a Manzoni acolyte Turk has produced his own stool in a jar, has made art works out of his own signature and has even forged Manzoni's own. He's stolen Manzoni's egg, and his white reliefs (the Achromes). Second time around aren't these formerly simple and apparently supreme acts of authorship just a little pathetic, nerdy even? Sunday painters, if nothing else, are at least acquiring some kind of skill or technique by copying a good Impressionist, but come on Gavin, everyone knows how to sign their name and lay a turd. If you're going to plagiarise someone else's work at least make it difficult. If you've got stars in your eyes make sure they're Shirley's, Barbara's or Celine's.

So what is going on in Gavin Turk's cover versions? Remember Jasper Johns' painted bronze sculpture of his brushes dipped in a tin of turps? Well Turk has done two bronzes of a paint roller instead. One an actual roller coated with a fine layer of bronze powder (reversing Johns' procedure), entitled **Gavin Turk's 9" Roller in Bronze**, the other left bare, ironically true to its material. With Johns the brushes hover enigmatically between brush and sculpture, between original art work and banal object, between signifier and signified. But however bifurcated and reflexive, the piece at least alludes to the traditional tools of the artist and so the discussion remains within the confines of the object. A roller though belongs to the worlds of painting and decorating, not to Fine Art, and when in a gallery it refers to whitening the walls in preparation of an exhibition, or preparing a modern minimal plinth to display a sculpture. In other words it points to what surrounds art objects, which is supposed to be beyond the bounds of scrutiny, yet which has the discursive authority to identify as art those objects within its frame. Turk's three roller pieces sit on

plinths under glass lids posing as art objects. One is an actual paint-soaked roller sitting in a tray of white emulsion (this time accompanied by two brushes), which rests on an unpainted wooden plinth under a glass top. It is as if the roller is about to paint the plinth white so that it can more properly identify as art that which it displays. In this tautology the art object is apparently there at the service of the frame.

Biographical anecdote has also come to frame the work of some artists, especially the best known. Manzoni's death from gluttony in his early thirties (he lied about his age), Warhol's shooting in 1968, Dali's bizarre masochism, Beuys' crash in his Stukka fighter plane in arctic Russia and his convalescence under the supervision of nomadic tribesmen. Usually the recitation of these events conspire to inflate the critical and commercial worth of the art works. Much of the significance of Joseph Beuys' work relies on a mythification of an accident of history which has in turn accorded the artist the status of a shaman, and imbued the objects he produced with the aura of holy relics. The assorted things in his vitrines remain banal and obscure without access to the gospel that produces their meaning.

When Gavin Turk re-stages this elevating process second time around the superstition and smoke and mirrors are glaringly apparent. Turk is like a medieval charlatan in the business of manufacturing false relics. In place of Yves Klein's **Leap Into The Void** (itself a faked photograph of the artist diving from a first floor window), Turk presents a video of himself being levitated by a television conjurer with the aid of a pink fluorescent hoop. Or else a pair of crutches stands on display as part of a piece entitled **Munchausen's Robin** which was the residue of an 'accident' the details of which he faxed himself care of a gallery a few hours prior to the actual event. After the accident and before the exhibition the artist walked with crutches at all times for a duration of two weeks. Like those afflicted with Munchausen's Syndrome whose obsession with hospitals leads them to fake infirmity in order

to undergo treatment, Gavin Turk's constructed events reverse the relationship between cause and effect, action and object, biography and myth.

Sometimes he quite literally raids art history's dressing-up box: he greeted a group of 'ordinary people' who were curating a contemporary art show for the BBC in a Dali moustache, which he afterwards framed and presented as a relic of the performance. In doing so he acted up to a populist conception of the identity of artists, whilst disguising his own, thus pre-empting some of the programme's underlying assumptions about artist and audience. Although one of many spin-offs or asides from some of his more central concerns the piece efficiently satirises the media cultivation of the artist as eccentric or clown whose sartorial appendages – pointy moustaches, silver wigs, bleached hair – frame and in some cases precede the art works themselves.

Camouflage Self-Portrait (A Man Like Mr. Kurtz) is a photograph of Gavin Turk's head against a black background, his face covered in patches of cosmetic mud-pack like army camouflage. The piece alludes to Warhol's self-portraits which underlay his features with camouflage in vivid colours. As with many of Turk's more recent works the single reference is opened up to a number of contradictory readings that together chart a complex semiotic/cultural voyage. Camouflage, originally, is a kind of abstraction of the landscape used to hide soldiers and vehicles from the enemy. Its roots are in observing the appearances of animals. As a hybrid of the abstract and representational, and as a quotidian form of painting, Warhol's appropriation of camouflage deconstructed the ideology of autonomy that framed abstract painting. His use of vivid, altered colour schemes rendered it both camp and psychedelic, thus also subverting its military use and identity. In Turk's photograph he partially returns the image back to its source in another act of self-effacement. He also brings in further cultural dimensions to camouflage and khaki by evoking

Marlon Brando's portrayal of Mr. Kurtz in **Apocalypse Now** itself a Vietnam update of an earlier work, Joseph Conrad's novel, **Heart of Darkness**. Vietnam veterans and many others, including John Lennon around the time of **Give Peace a Chance**, wore army fatigues with long hair as a pacifist inversion of military code. This was again taken up by New Age 'travellers' in Britain in the late Eighties. Now in the Nineties combat trousers are worn by pop stars and fashion conscious city dwellers. Camouflage, stripped of its function and reference, becomes just a pure, promiscuous image.

In Britain art has never been regarded as a serious pursuit. Call yourself an artist and you can't help but hear the prefix 'piss'. However polite and domesticated Britain's version of Modernism, the artist in Britain has never felt at home. How could we have expected 'our boys' to have leapt into the void or christened a colour 'International Klein Blue (I.K.B.)' at the height of experimental bullishness elsewhere? For heroic guises Turk has had to look abroad to America, France, Italy or Spain. Mix the traditionalist iconography of Britishness – the flag, our tabloids, the royals – with lofty Modernism and you get a contradiction of hostile terms, as in Turk's **Indoor Flag** a painting of a limp Union Jack against a starch-white ground whose blues are made of I.K.B. pigment. Gavin Turk is of the generation of British artists who knew of Carl Andre as the one whose 'bricks' were trashed by British tabloids before they knew of him as the American Minimalist. Turk plays Andre's ambivalent avenger with his piece **Window** which superimposes Turk's own face onto that of a British soldier at the centre of a Union Jack which filled the whole front page of a notorious issue of **The Sun** at the height of the Gulf War. The paper carried the instruction 'support our boys and put this flag in your window'. Many did. On Turk's head the army beret becomes that clichéd attire of the Parisian avant-garde painter which was imitated by some in St. Ives

a little later, but never really gained much of a foothold in this country elsewhere.

The increasing fame and success of the Nineties generation of British artists is built upon an iconography of failure. Most of the current work registers resignation to the fact that 'our boys' (and girls) will never be accorded centrality in our own culture, however much the international art world thinks they swing. What has usually been most admired in British popular and 'avant-garde' culture tends to mark a distance from and scepticism towards the modes of freedom and transcendence that American and Continental cultures have proposed. Perhaps the most extreme icon of post-Imperial British disenchantment is Sid Vicious. Where else might glamour coalesce so naturally around an embodiment of apathetic, inarticulate, self-destructive nihilism? Gavin Turk's **Pop** is a waxwork portrait of himself as Sid Vicious singing Sinatra's **My Way** in **The Rock 'n' Roll Swindle**, in the pose of Elvis playing the part of a cowboy in a movie as silk-screened by Andy Warhol (phew!). All these allusions are embodied within the broader pastiche of a Madame Tussaud/Rock Circus aesthetic, which in turn is housed in an ethnographic-style glass display case. As attention around the post-**Freeze** generation of artists has escalated, so Turk's semiotic Frankenstein has become something of an icon for the problematic status of the young post-Modern artist working in a culture that never really recognised Modernism itself. **At The End of the Twentieth Century** (a title of another sculpture by Turk of a melted modernist plinth), the British artist probably really does relate more easily to our own Sid Vicious or Madame Tussaud, than to Andy Warhol or Elvis Presley.

This preoccupation with the social failure of Modernism in Britain has emerged more fully in Turk's work since **Pop**. As his earlier recyclings of famous avant-garde moments have themselves become known in critical quarters, the Manzoni, Klein, Johns and Warhol disguises have lifted to reveal, ironically, a classically-authored body of work. As Turk's own signature has become commodified so the role of the cultural parasite passing from host to host no longer functions as a critique of originality from a position of anonymity and remove. Where Turk was embarrassingly overdressed before, he now appears unacceptably underdressed. **Oi!** is a triptych of life-size photographs of the artist dressed as a tramp, one eyelid closed, pointing a limp finger at a half-imagined adversary, mirroring the stance of Sid in **Pop**. The piece developed out of his uncommissioned performance as a wino at the private view of **Sensation** at the Royal Academy. The mammoth exhibition was widely considered the apotheosis of the young British artist scene, and its institutional absorption. Turk's 'performance' – which is what much private view behaviour in any case is – pointed towards the confused social identity of today's artists who might find themselves entertained at a rich collector's home only to find they cannot find the bus fare home. **Bum** is the waxwork version of **Oi!**. The pose echoes an inebriated **Pop**. It is a verisimilitude of Turk in the guise of a tramp, wearing some of his own old clothes. The clothes have been subjected to processes reminiscent of 60s body art: Turk has urinated in the trousers and worked up some rancid underarm sweat to achieve a mock-abject trace of his own corporeality in what is otherwise simulacra.

A third waxwork in progress is a glass-cased tableau transcription of Jacques-Louis David's **Death of Marat** (1793), that tragic masterpiece of neo-classical painting. Gavin Turk lies in place of the murdered martyr of the French Revolution, not dead, just asleep. The tub is an ordinary bathtub and it extends beyond the edges of the scene David depicted. The floor is tiled in mundane grey linoleum, and the bathwater remains unbloodied. Within what has become a banal scene lie embedded at least two more artistic recyclings. The drapery which hangs off the bath like bedding in David's painting

is reminiscent of Alberto Burri's 'matter' paintings, while the inscribed block in the painting now resembles a neo-classical pedestal by the contemporary Scottish sculptor Ian Hamilton Finlay. Like **Pop** the piece is a vertiginous essay in representation. This time it's a representation of Madame Tussaud representing David, her contemporary, via Sixties American Assemblage (Kienholz, Hanson, Segal). Turk is able to fold an image of his own identity into that of Marat's by appropriating a sequence of incongruous realisms – assemblage, waxwork, classical portrait – and by throwing in his own additional realist style, the readymade. Each on their own terms call on viewers to believe that they are in the presence of a 'real' scene. Superimposed, each unravels the others' claim on reality.

This heightened awareness of representation mirrors the entwined destinies of Marat's image and Tussaud's cultural legacy. (Tussaud's own wax portrait of Marat, made in the same year David painted his, can be seen today at her museum on Marylebone Road). In both cases Tussaud's and Marat's place in two very different narratives of representation – Fine Art and entertainment spectacle – has all but erased their historical identities. Madame Tussaud made her wax portraits for the French court shortly before the Revolution. To survive the aftermath she concealed her Royalist past by making deathmasks of decapitated aristocrats for the Republicans. Some are thought to have been incorporated in the original Chambers of Horrors. (The very Warholian celebrity/death twin tiers of the Madame Tussaud Museum can be seen in terms of the Revolution, before and after). Today both David's painting and Tussaud's waxwork version of it have followed their own representational destinies. As icons they are now largely unstuck from their origins and historical contexts. Via reproduction and tourism they are now independent images which we observe with the nonchalance of the over-entertained at the fag end of history.

**Pimp**, strangely, is perhaps Gavin Turk's most idealistic piece. It is simply a skip that has been given a smooth, gleaming coat of black paint. Here for once, apparently, the tables of degradation are turned, and this ugly, ubiquitous symbol of urban waste and disruption is presented as a sexy, abstract, retro piece of painted steel sculpture. Its shiny surfaces lend an otherwise lumbering mass the illusion of weightlessness as if it might glide through space; its angular plates suggest a folded, futuristic bird. But like an empty vitrine or bare plinth, there is again the sense of frames and the absence of actual art works originated by the artist. It's an empty container, a **Pimp** or purveyor perhaps of abandoned moments of art history. Here though it's empty, a Void, devoid of the tangle of references and recyclings that together make up Turk's secondary aesthetic. For an instant we are presented with a vacuum amid the convolutions, a container containing emptiness at the end of an avant-garde that has worn itself out.

# Gavin Turk's Studio

*Joshua Compston/Factual Nonsense 1996*

Left out of the Marquee onto the sausages of the Charing Cross Road lies a block and a studio steeped in many of the flavours responsible for today's Barabarella art world.

Bounded on one side by the filth that Camden Council cleaned away, on another by St. Giles High Street and bisected by an alley, Denmark Place, that steams with positively horrible associations, it is abruptly ended by the cheeky chappy's Denmark Street, domain of Tin Pan Alley, Andy's Guitars and Frieze Art and Culture Magazine (where lies the difference?). 142 Charing Cross Road is a rotting pile of late Victorian masonry. It is here that the famous Surrey dissident, Gavin Turk, occupies a form of terra firma.

Situated adjacent to 148 Charing Cross Road, a hybrid structure with a remarkable hat for a roof, since 1993 home of the art cult dive 'Poster Studio', this man was one of the first to peer into this House of Usher. Perched in tension against the window of his second floor studio, the smell of Perfect Fried Chicken gently gluing the mortar and my interrogation together, he regales me with the stories of how, when all else fails, contemporary art moves in.

Cluster bombs pock marking the skin of bourgeois consciousness: in the last few years the area covered by the flying fat has encompassed in 148 the launch of Sarah Staton's **Supastore**; an optimistic version of an artist's supermarket, Curtis Turk's baby shower, with the young star himself regally nestled in a lime green fibreglass throne, **Submission Parties** with a really painful gym and 'social engineering' via a proposal for an on site sculpture garden with entries submitted by Sarah Lucas, amongst others.

Underneath these actions in 144 Charing Cross Road the legendary Lawren Maben ran his empire, Milch, with an attractive mixture of class A, speculative erudition and psychotic masculinity: he was heavily involved with getting 'fisted', setting up artist studios and inspiring those around him with a rare breed of purifying violence. Since his fatal overdose his lover, Bernard, has continued to provide the milk to make you grow: his last project in December was a showing of **Crawl Space**, a disturbing, 'neo-gothic' Jane and Louise Wilson video originally made for Sugar Records.

Confronted with such surroundings one might expect the actual building that Turk occupies to be a haven of graceful clichés: 'Yeah, I get in everyday around 10 and prepare water-colour paper for the first few hours and then… ' However a quick survey of pertinent names: 'The Artistes and Repertoire Club' and 'Abigail Wimbourne's Lovely Girls Always', reveal that these entities are past tenants of the same building. Strange requests still arrive from Nigeria in Commonwealth English for Mojos, evidence of the previous occupancy of the, 'Ancient Order of Lemme Star'. Such mail displays a certain lack of safety in the atmospheric 'cleanliness' of the surroundings.

An apt inheritance therefore for an artist whose output displays a mastery of the 'blur' technique, a cunning symbolism that is not post-Modern in the redundant and childish sense of a Salle or a Schnabel. Turk's studio and art, the poignancy that surrounds it and the way that he puts it all to use, add to the creation of a surface worth examining for its stitches and intricacies. The building, like its neighbours, is condemned short life stock and is managed by a charity, Acave, whose aim is to bring the 'virtues' of art to the communities it dwells amongst. Perhaps aware of this hazy code, the studio, chosen for its proximity to the necessities of London life ('What weirdo would want to work in E17?') has acted out an inspired role since Turk's restoration of the room in 1992.

Indeed at times it smells like the place has been a centre for fond invigoration: in one corner is a shelf upon which the very beautiful Curtis Turk was conceived; a fact commemorated by Curtis' second name, Charing. The infamous nomadic Jewish artist, Dan Asher (named by one wag

'Asher Pile' for reasons of his formless shape) is wont to clutter the place with his suitcase libraries, whilst one well known London impresario, when travelling through on coke binges, used to harangue him until the stupid hours, before going off over the roofs to smash windows. Vodka driven 'office parties' have been hosted and Gilbert and George have also been known to come for a cackle.

All this managed to slip in whilst such important pieces as **Pop**, his sculpture of himself as Sid Vicious as etc. was being modelled and occult levitating practices were being perfected for the work that formed the basis of his White Cube show, **A Marvellous Force of Nature**. Visitors at the time recall a disconcerting mixture of limbs, clothes and other paraphernalia strewn around with casual abandon.

However, it is perhaps the four exhibitions for fellow artists that have been presented within the studio that most aptly demonstrate its public side. Conceived within the spirit of enterprise operating outside the concerns of either commerce's glaring lights or the grotty uncertainties of the so called 'alternative scene', solo shows have been awarded to artists such as Renato Nhiemis, whose sly model of an art gallery now resides in the Saatchi Collection. Turk speaks of this practice of showcasing others art as being analogous to being 'in and out of love', it's 'problem and its strength', but it is an adjunct essentially generous in its conception.

His last project, **Gavin Turk Painting Collection Celebrity Charity Gala Evening**, which opened to a spiralling J and B aplomb in December was perhaps the most ambitious and left field to date. The once immaculate white walls were merrily obliterated with garish burgundy paint in parody of a Salon. Upon this painful surface were hung a dolly mixture of images by Bartlett architecture students pretending to be painters in order to make a 'pseudo-psychological painting environment'. Amongst these was one that suitably embodied the shows formal irreverence: Dan Rochard's work **Jenny, Barbara and Cindy – strange isn't it the way they follow you round the room**, displayed the breasts of three prominent New York based artists of the 80s. As a way of wetting the palates of the celebrities who bought these works via bid to benefit an AIDS charity, paintings by artists such as Gary Hume and Sarah Staton were also included. Even the most classical work, a sensitive study of hands by Deborah Curtis – Turk's beautiful girlfriend often compared by the media to Isabella Rosellini had a certain putrefying quality to it.

Whilst surveying the Soho rooftops, I'm told that future projects for the studio may include: a Drugs Bar, a Judo Workshop, 'germ cell dinner parties' and a Dan Flavin show of a 60s neon piece in the shape of a 'T'. Strikes me as probable that Yves Klein might have come to an earlier tea party, perhaps at the very point where **Lovely Girls Always** were replaced with **Lovely Ideas Always**. Perhaps one day he'll charge for his personal services.

Until then you can freely climb past Perfect Fried Chicken.

hello | 1994
colour copy, acrylic, steel and cloth
100 x 50 x 70cm

identity crisis | 1994
screen print in light box
172 x 112cm

0123456789

0123456789

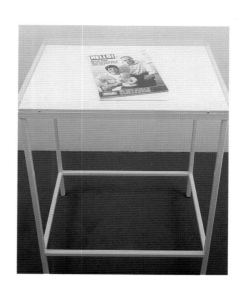

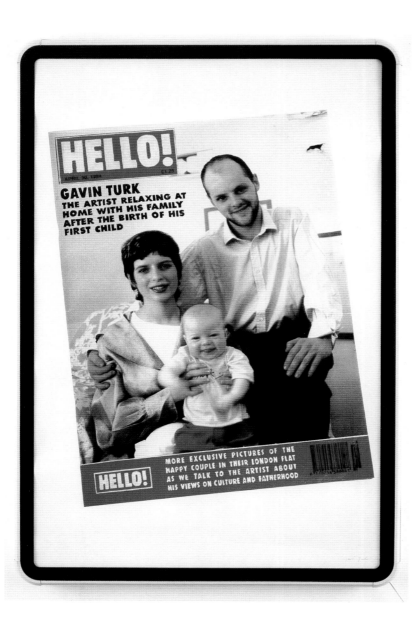

indoor flag

1995
oil paint and international klein blue pigment on canvas
107 x 168cm

0123456789
0123456789

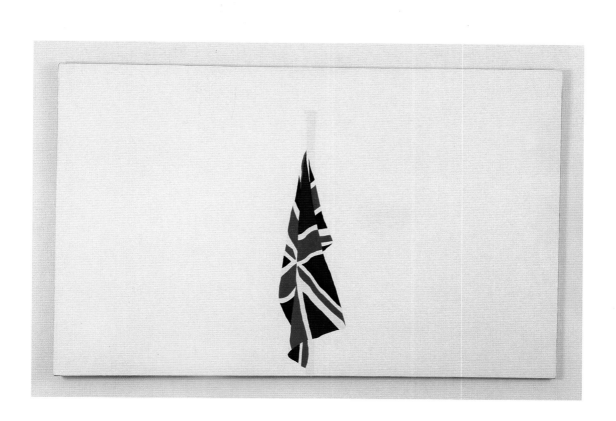

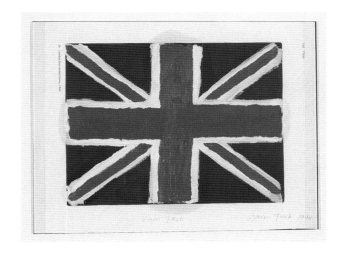

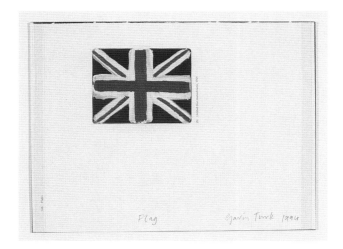

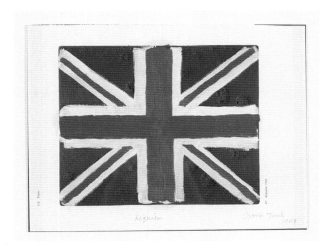

stretcher | 1994
paint and biro on paper
21 x 29.5cm

union jack | 1994
oil on paper
21 x 29.5cm

the flag | 1994
oil on paper
21 x 29.5cm

requiem | 1994
oil on paper
21 x 29.5cm

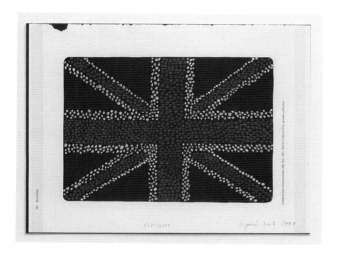

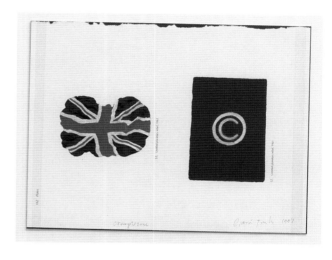

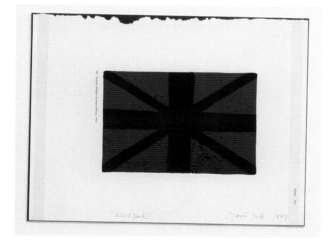

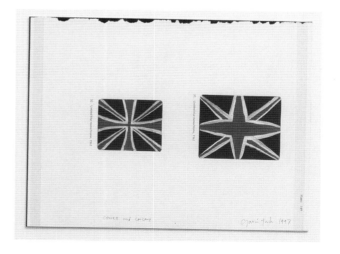

rosicross | 1997
oil on paper
21 x 28cm

crumple zone | 1997
oil on paper
21 x 28cm

black jack | 1997
oil on paper
21 x 28cm

convex and concave | 1997
oil on paper
21 x 28cm

paint, two rollers and brush | 1995
paint, two rollers, brush and vitrine
vitrine: 111.5 x 86.5 x 48.5cm

gavin turk's 9" roller in bronze | 1995
roller, bronze powder, glue, paint and vitrine
vitrine: 129 x 67 x 45cm

bronze roller | 1998
cast bronze and vitrine
vitrine: 150 x 59 x 46cm

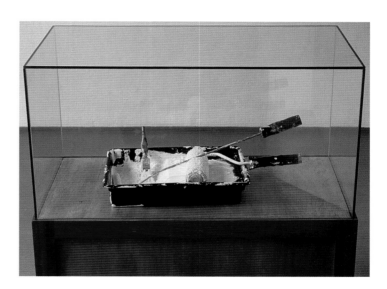

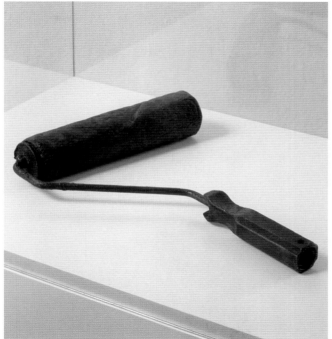

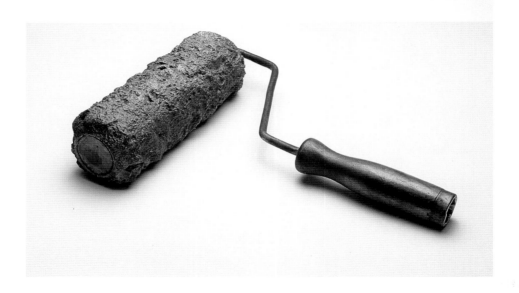

dopple egg

1995
duck eggs and vitrine
vitrine: 42.3 x 49.3 x 19.5cm

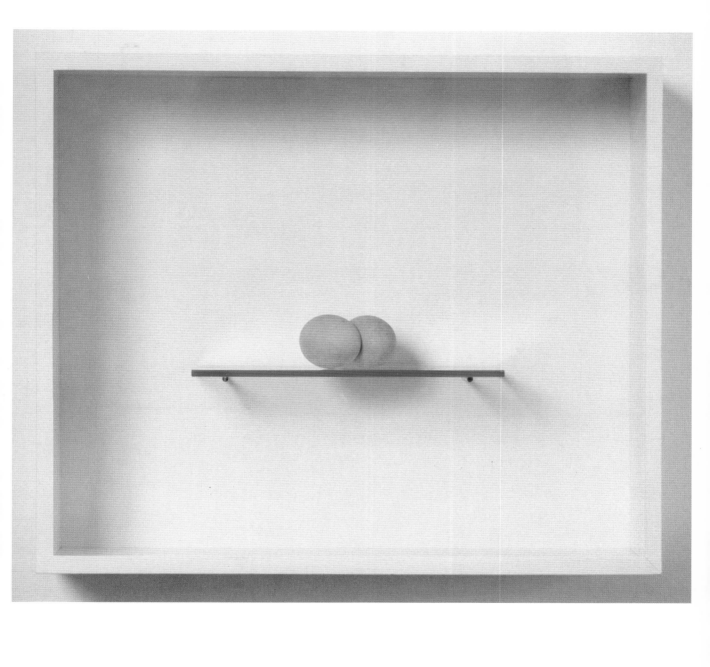

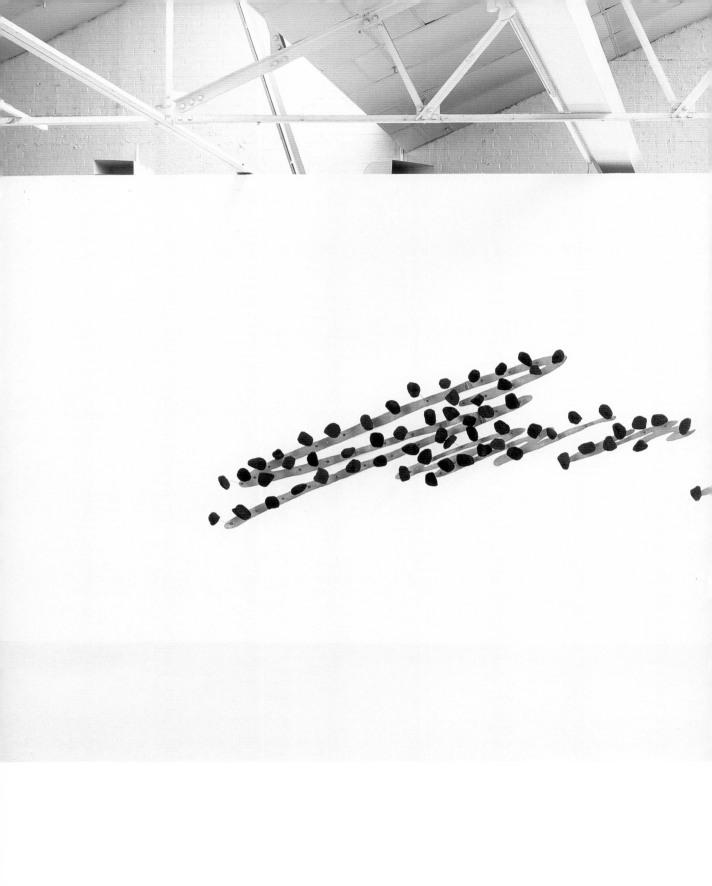

unoriginal signature | 1996
steel, natural sponges and pigment paint
accompanied by working drawing
approx. dims. 180.1 x 900cm

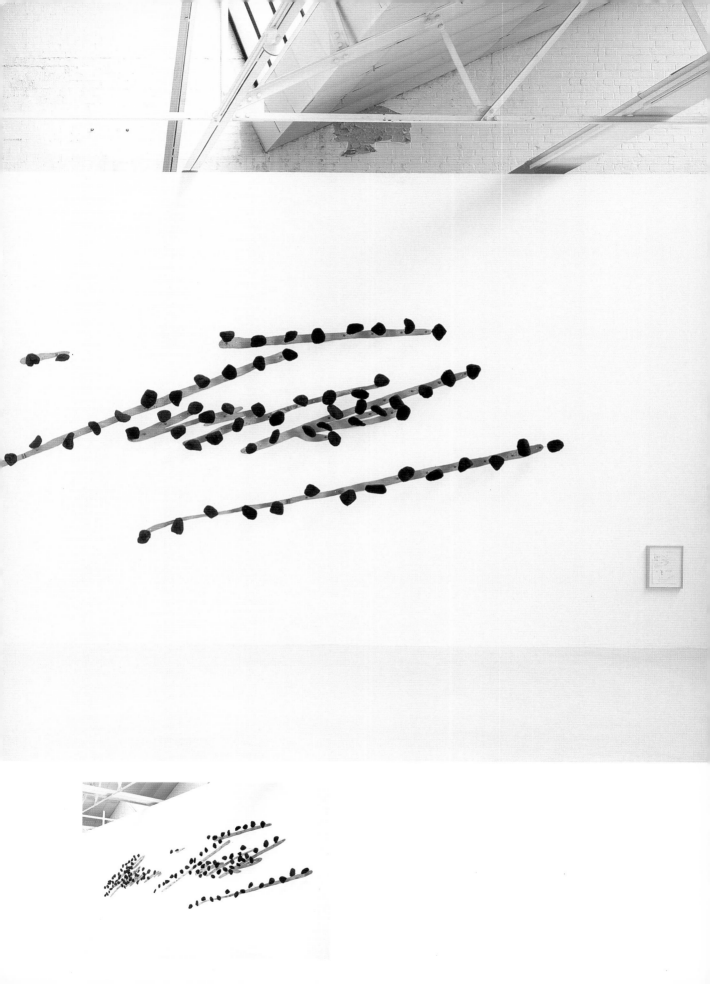

0123456789
0123456789

godot | 1996
c-type colour print
100 x 76cm

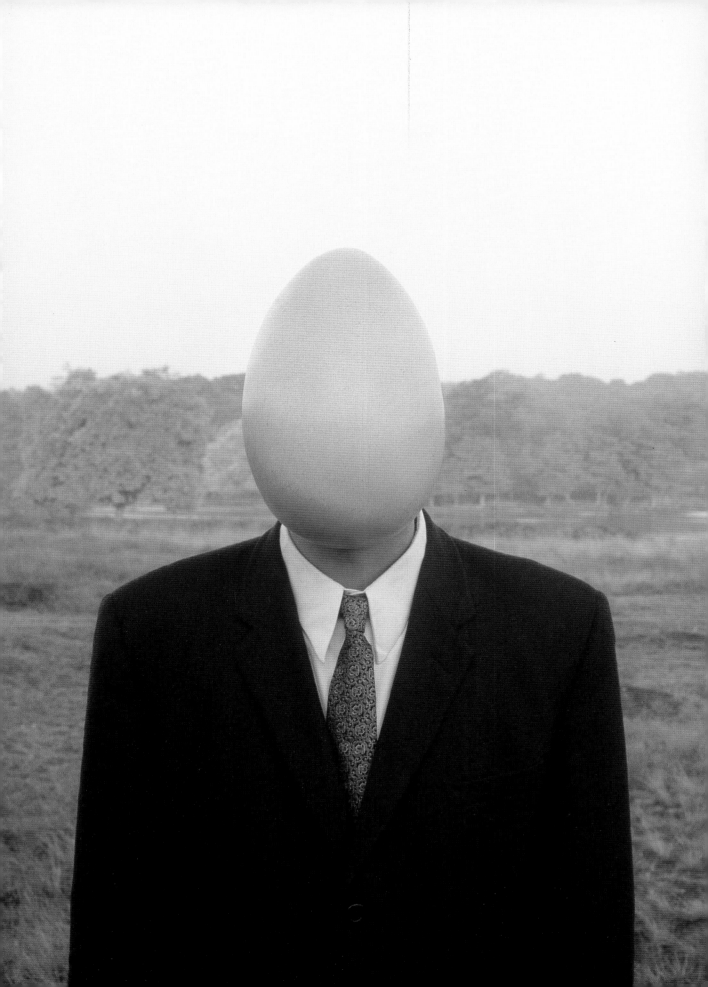

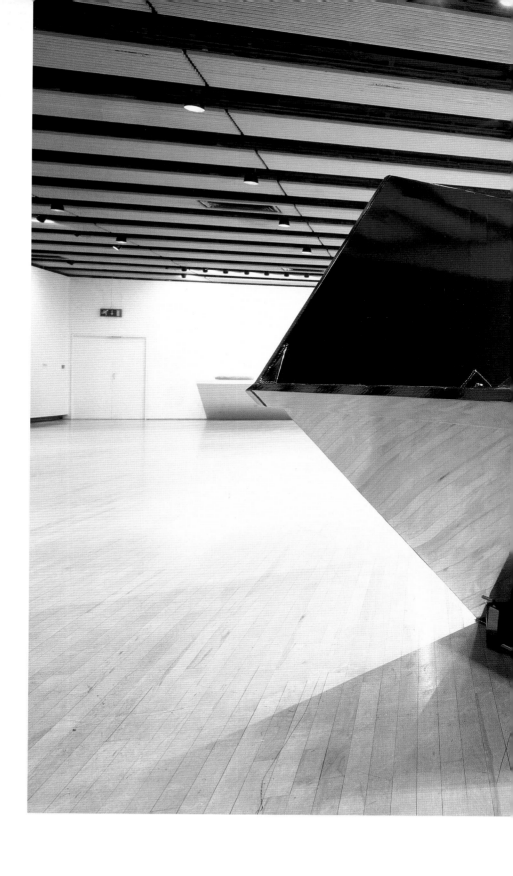

pimp | 1996
painted steel
183.5 x 373 x 184cm

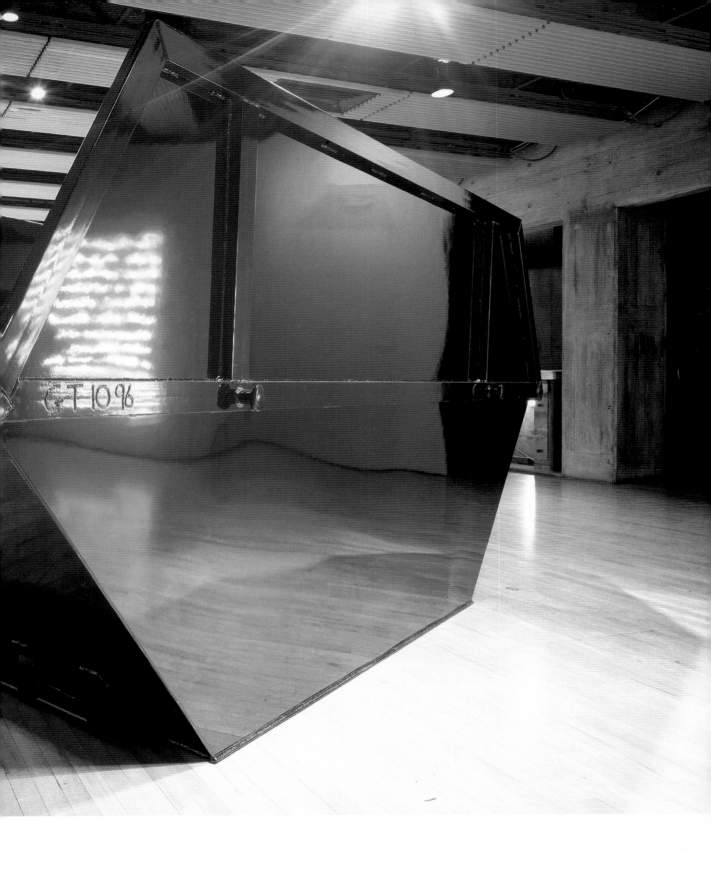

gt 2 | 1997
polystyrene balls and polymer paint on canvas
92 x 122cm

0123456789
0123456789

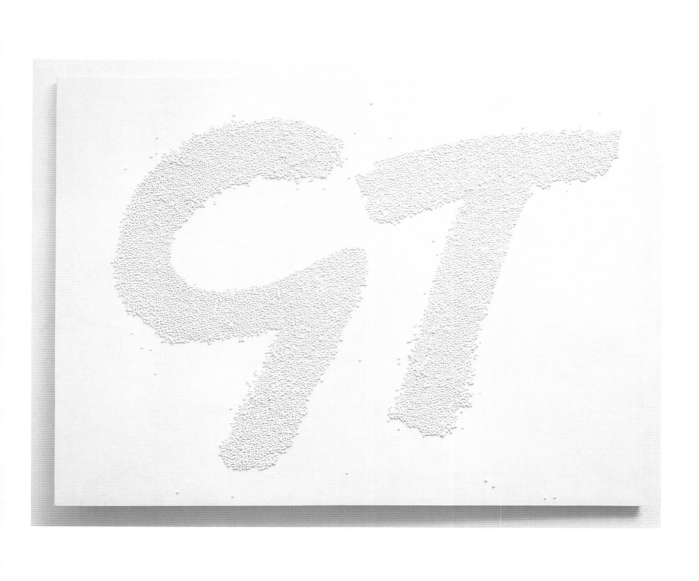

constellation | 1997
polystyrene balls and polymer paint on canvas
183 x 396cm

0 1 2 **3** 4 5 6 7 8 9
0 1 2 3 **4** 5 6 7 8 9

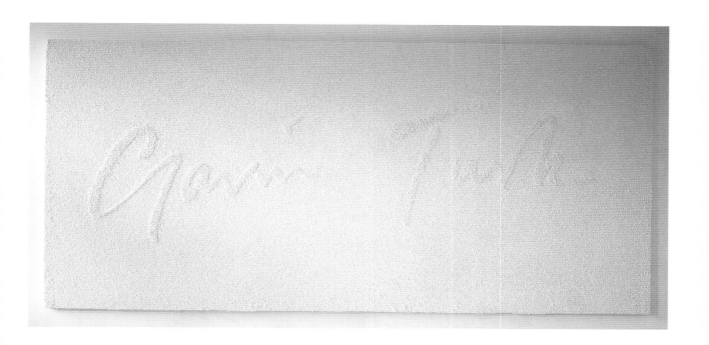

gavin turk

1997
polystyrene balls and polymer paint on canvas
153 x 213cm

g.t.e.g.g. | 1997
egg shell on canvas
107 x 137cm

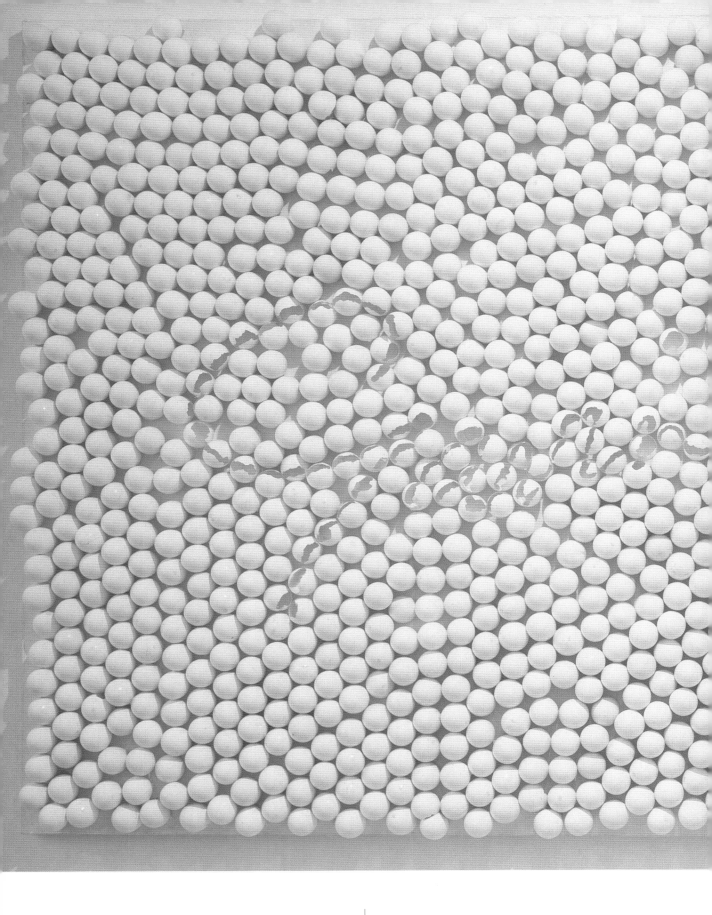

one thousand, two hundred and thirty four eggs

1997
egg shell on canvas
132 x 221cm

0123**4**56789        **0**123456789

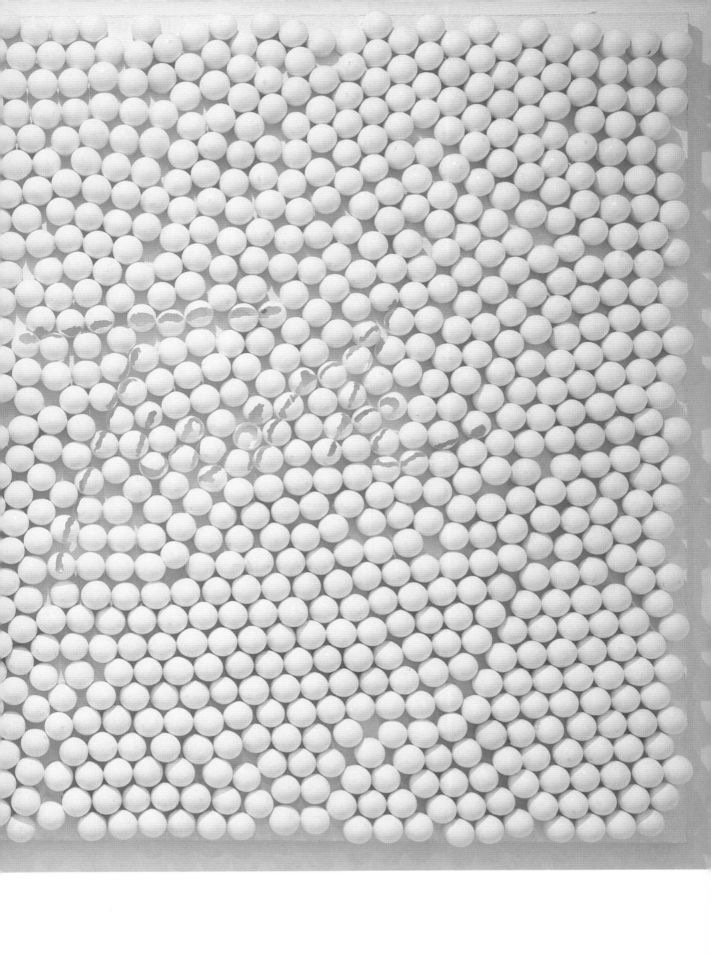

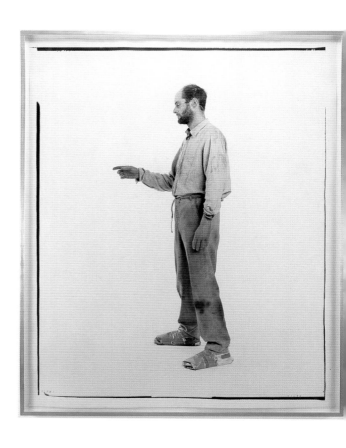

oi! | 1998
r-type colour prints
244 x 197cm

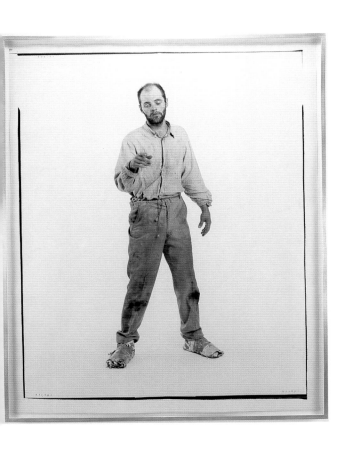 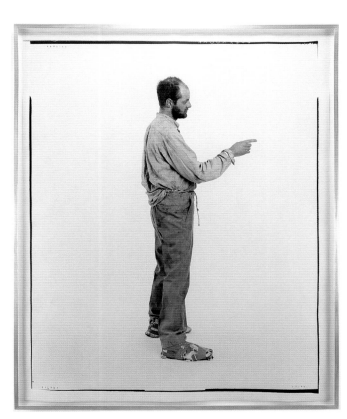

eight boxes | 1997
watercolour on paper
dimensions variable

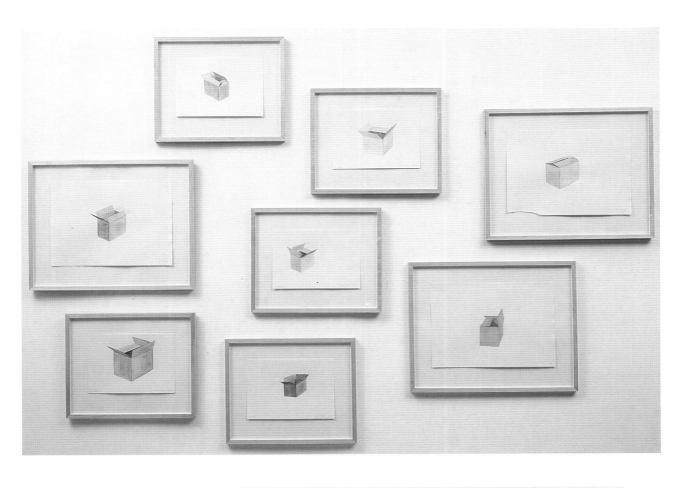

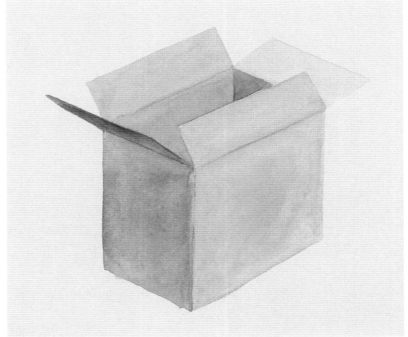

ballad of a star | 1997
oil on canvas
102 x 76.5 cm

0123456789
0123456789

a b c d e

f g h i j

k l m n o

p q r s t

u v w x y z

white ballad of a star | 1997
paint on canvas
100 x 75cm

0123456789
0123456789

g

t

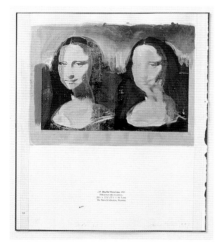

portrait of him | 1997
liquid acrylic on paper
28 x 23cm

the big chair electric | 1997
liquid acrylic on paper
28 x 23cm

double act | 1997
liquid acrylic on paper
28 x 23cm

floral tribute | 1997
liquid acrylic on paper
28 x 23cm

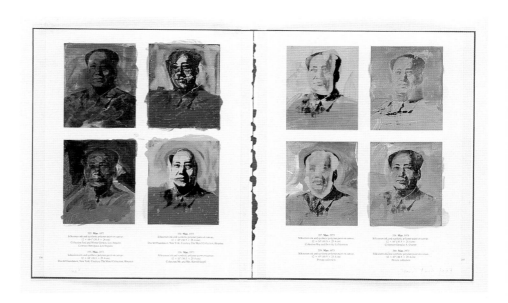

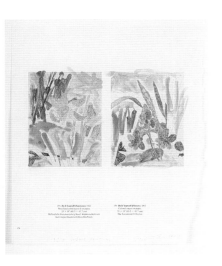

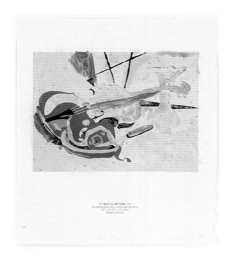

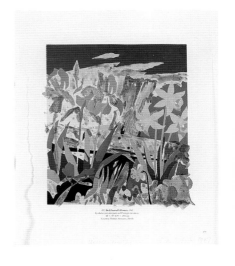

mao to the power of eight | 1997
liquid acrylic on paper
28 x 48.5cm

2 diy undone painting | 1997
watercolour on paper
28 x 24cm

violin painting | 1997
watercolour on paper
28 x 24cm

undone painting | 1997
watercolour on paper
28 x 24cm

portrait of something that i'll never really see

1997
c-type colour print
90 x 90cm

0123456789
0123456789

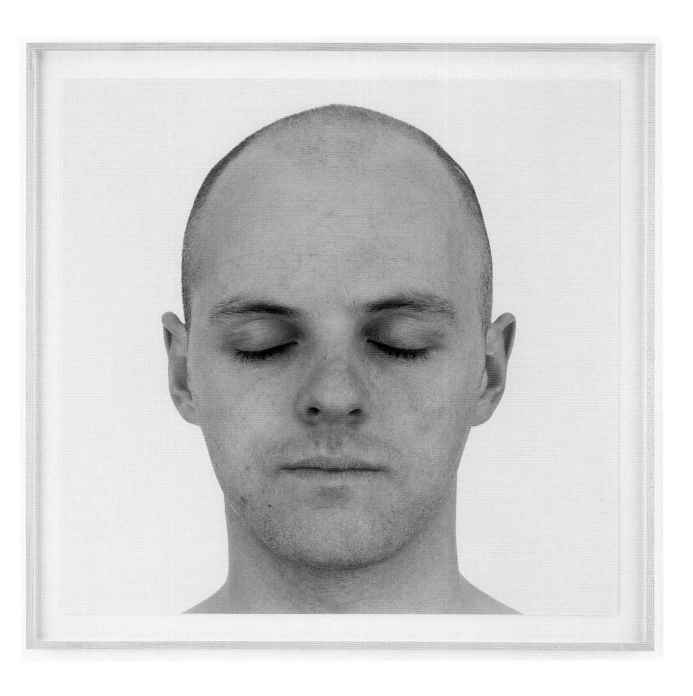

UOVO

1998
wood and resin
32 x 42 x 32cm

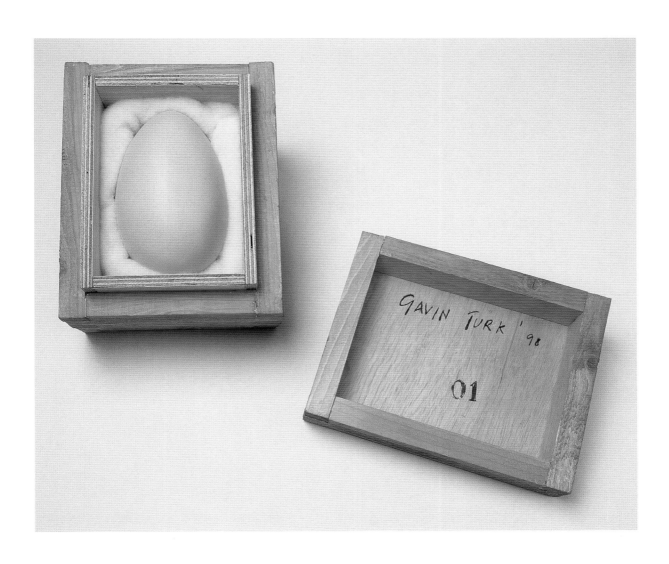

camouflage (self-portrait)

1998
r-type colour print
90 x90cm

camouflage self-portrait (a man like mr. kurtz)

1994
cybatrans mounted in lightbox
101.7 x 101.7cm

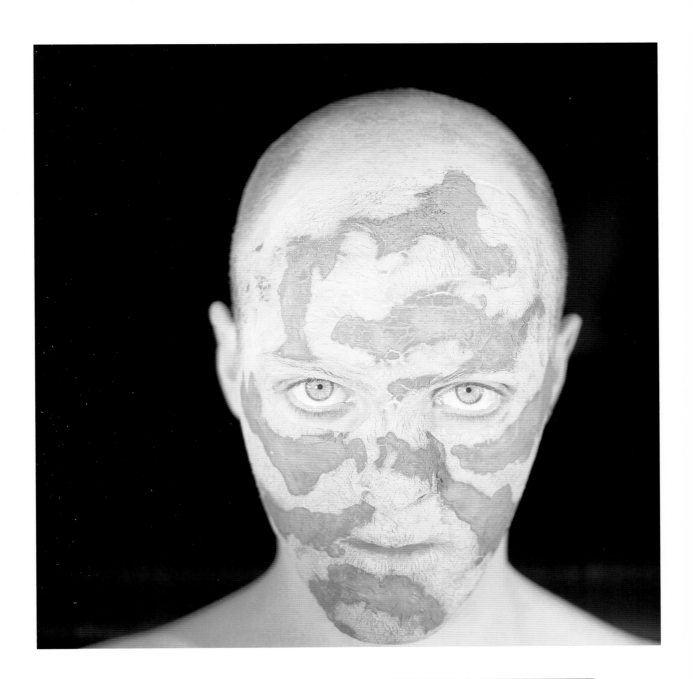

pk 1 | 1998
resin and cellulose paint
65 x 60 x 25cm

pk 2 | 1998
resin and cellulose paint
58 x 50 x 26cm

bum | 1998
waxwork
167 x 70 x 70cm

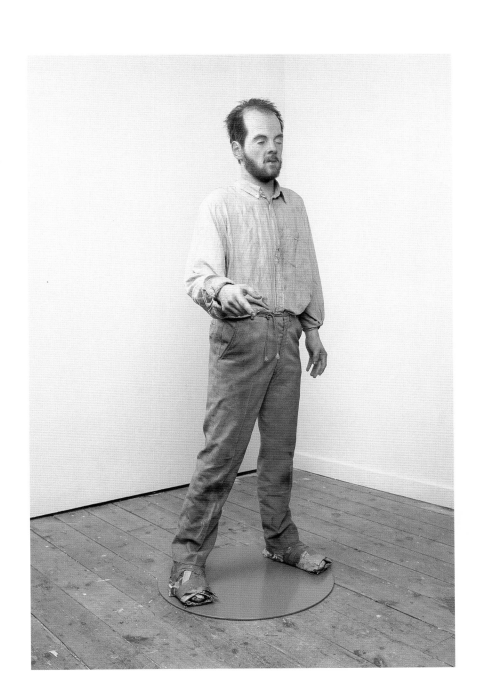

the death of marat | 1998
mixed media and vitrine
vitrine: 200 x 250 x 170cm

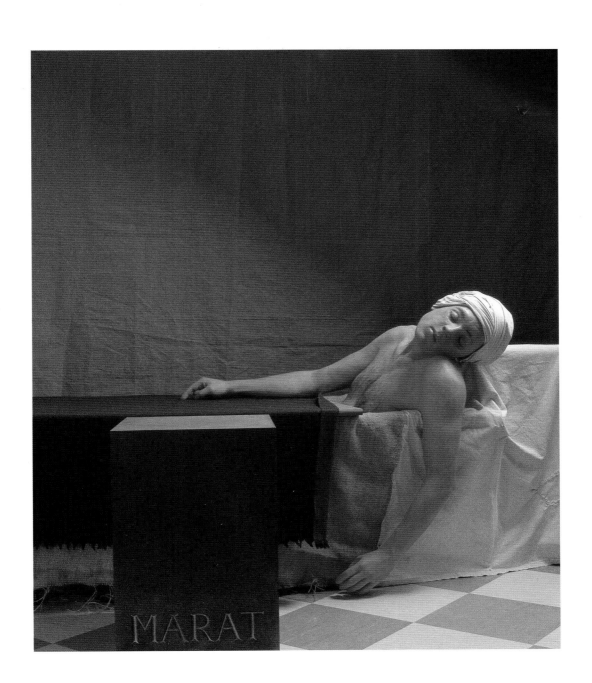

1967　Born, Guildford
1991　Graduated, Royal College of Art, London
　　　Currently lives and works in London

## Solo Exhibitions

1997　**Gavin Turk**, Charing Cross Road, London, April
　　　**Gavin Turk**, Charing Cross Road, London, December

1996　**Unoriginal Signature**, Habitat, Kings Road, London
　　　**Gavin Turk,** (Part of British Art in Rome) Galleria D'Art De
　　　Crescenzo & Viesti, Rome [exh.cat.]

1995　**Turkish**, Aurel Schiebler, Cologne

1993/94 **Collected Works 1989-1993**,
　　　Jay Jopling, Denmark Street, London [exh.cat.]

1993　**A Marvellous Force of Nature**,
　　　White Cube/Jay Jopling, London
　　　**A Night out with Gavin Turk**, Victoria Public House,
　　　Bapisha Gosh, London and Schiefer Haus, Cologne

1992　**Signature**, Bipasha Ghosh/Jay Jopling, London

## Group Exhibitions

1998　**Contemporary British Art Exhibition**,
　　　National Museum of Contemporary Art, Korea [exh.cat.]
　　　**Bathroom**, Thomas Healy Gallery, New York
　　　**Feeringbury VIII. Cultivated**, Feeringbury Manor,
　　　Feering and Firstsite, Colchester [exh.cat.]
　　　**Drawing Itself**, London Institute Gallery, London [exh.cat.]
　　　**Heatwave**, The Waiting Room, School of Art and Design,
　　　University of Wolverhampton; Shoreditch Electricity
　　　Showrooms, Hoxton Square, London
　　　**Camouflage 2000**, Galerie Praz-Delavallade, Paris

1997　**Sensation. Young British Artists from the Saatchi
　　　Collection**, Royal Academy of Arts, London; Hamburger
　　　Bahnhof, Museum für Gegenwart, Berlin [exh.cat.]
　　　**Material Culture**, Hayward Gallery, London [exh.cat.]
　　　**Renovate**, Shoreditch Town Hall, London
　　　**Dissolution**, Laurent Delaye Gallery, London
　　　**Mutants**, Galerie Philippe Rizzo, Paris
　　　**All of a Sudden II**, Galerie Aurel Scheibler, Cologne

1996　**Plastic**, Richard Salmon, London;
　　　Arnolfini Gallery, Bristol [exh.cat.]
　　　**Other Men's Flowers**, Aurel Scheibler, Cologne;
　　　The British School at Rome, Rome
　　　**Private View**, The Bowes Museum/Henry Moore
　　　Institute, Leeds [exh.cat.]
　　　**Two Seconds. Nine Months**, Bankside, London
　　　**Fuck Off**, Bank, London [exh.cat.]
　　　**Museum Vitale**, Museum Schloß Morsbroich,
　　　Leverkusen [exh.cat.]
　　　**All of a Sudden**, Aurel Scheibler, Cologne
　　　**Sex & Crime**, Sprengel Museum, Hannover
　　　**Works on Paper**, Irish Museum of Modern Art,
　　　Dublin [exh.cat.]

1995　**Young British Artists III**, Saatchi Gallery,
　　　London [exh.cat.]
　　　**Mito**, Museo Dell'arredo, Ravenna
　　　**Hardcore (Part II)**, Factual Nonsense, London
　　　**Other Men's Flowers**, Icebox, Athens
　　　**Beauty is Fluid**, Dering Street, London
　　　**Contemporary British Art in Print**, Scottish National
　　　Gallery of Modern Art, Edinburgh; Yale Center for
　　　British Art, New Haven [exh.cat.]

1994　**Karaoke & Football**, Portikus, Frankfurt
　　　**The Shuttle**, Kunstlerhaus Bethanian, Berlin [exh.cat.]
　　　**The Fate Worse than Death**, Hoxton Square,
　　　London [exh.cat.]
　　　**Minatures**, The Agency, London
　　　**Other Men's Flowers**, Factual Nonsense, London

1992　**Seventeen**, Greenwich Street, New York [exh.cat.]
　　　**Molteplici/Cultura**, Speaker Project, Rome
　　　**Tattoo**, Jennifer Flay, Paris; Andrea Rosen, New York
　　　**London Portfolio**, Karsten Schubert, London
　　　**Il Mistero dei 100 Dollari Scomparsi**, GioMarconi,
　　　Milan [exh.cat.]

1991　**Dermot O'Brien, Gavin Turk, George Watson**,
　　　Clove Building, London

## Collections

British Council, London. Caldic Collection, Rotterdam.
Deutsche Bank, London. Refco Group, Chicago. Saatchi
Gallery, London. Victoria and Albert Museum, London.